Thorns and Flowers
By
Godwin Inyang

© 2019 Godwin Inyang
All Rights Reserved.

https://richriverbooks.blogspot.com

CONTENTS

(1) GOALS 5
(2) NEW YEAR 5
(3) NEXT YEAR 5
(4) ONE-MAN RIOT SQUAD 6
(5) THE ART OF LIVING 6
(6) UNITY IN DIVERSITY 6
(7) THORNS AND FLOWERS 7
(8) DAILY NEWS 7
(9) THE SURGEON 9
(10) MY TRUE PAL 9
(11) JANUARY – DECEMBER (ACROSTIC) 10
(12) RELIGION 12
(13) THIRTY YEARS AGO 13
(14) THE COMPLIANT TENANT 14
(15) ARTWORKS 16
(16) SPORTSMANSHIP 16
(17) ROSE IN A BIN 17
(18) LIFE IS A JUNGLE 18
(19) DEATH 19
(20) MY WINDOW 19
(21) NEEDLESS ARGUMENTS 19
(22) HAPPINESS IS ... 20
(23) FREEDOM OF THE STRAY 20
(24) TENT OF HOPE 21
(25) TONGUE IN CHEEK 22
(26) NOW IS THE TIME 23
(27) WE KNOW EACH OTHER 23
(28) PORTRAITS OF POLITICS 24
(29) SMOKY CHIMNEY 26
(30) THE INTERNET {TO EVERY CHILD} 27
(31) I'M YOUR FAN 27
(32) TRAVELS 28
(33) LIFE'S RAINBOW 28
(34) NATURE 28
(35) IMAGINATION 28
(36) POETRY, LORD OF WORDS 29
(37) MY PEN 29

(38) THE WORLD BEST 30
(39) THE TALEBEARER 31
(40) JUST WISHING CANNOT MAKE YOU A WRITER 31
(41) THE ONE THING I TRULY ENJOY 32
(42) WHAT REALLY MATTERS 32
(43) CITY WHIRLPOOL 33
(44) IMMATURITY 33
(45) POETRY RESTAURANT (ACROSTIC) 34
(46) VISIBLE IN A DARKROOM 34
(47) BEADS OF LOVE 35

(1) GOALS

I resolved a long time ago and deep
In my mind wrote it indelibly down
And let it through my pores and skull to seep
That unceasingly at my goals I'd pound

Till you'd hear at a distance their crunch
As they give in but still harder I'd punch;
No respite, louder on them I'd munch;
Like a starving man, goals to me are lunch.

I'd greedily bite them till they beg I stop;
I'd bite till the day to the grave I'd drop.

(2) NEW YEAR

Oh yeah, I'm here your much-sought-after New Year:
Though you must face it, somewhere someone
This moment might the end yet not near –
You've rain and snow, elsewhere might be dust and sun.

I'm here to tell you I'd heard these rants before;
They said: 'This New Year I'd work on every flaw;
I'd be tough on myself and reach every goal's door;
Yes, I'd grab all goodies from Fortune's maw.'

It's not the rants but common sense and iron will;
You lack them, my truck back to my den I'd just wheel.

(3) NEXT YEAR

Next year I would fly like a turbojet;
Hold it, show skills like a super footballer
Making sure a goal is every kick at the net –
The crowd everywhere must holler and holler.

I'd be an eagle swooping for a kill;
My antics would leave the audience with a thrill;
I'd drop all those gimcrack friends – I'd be real;
To all obnoxious habits I'd say nil.

But how do I say 'No!' to my dawdle?
Would I stop shifting blame but firm on my hustle?

(4) ONE-MAN RIOT SQUAD
It might not be about physique as such
But the mindset – you come gloating I fall
But I rise and rise; thinking I hit a hush
But I'm out making my most strident call.

Who told you I'm near what you could maim?
Who told you I'm within what you could tame?
You thought my psyche fits your silly game?
Well, know this, your thinking is really lame.

I'm a one-man riot squad – don't make noise;
When pushed to the wall, dreadful is my poise.

(5) THE ART OF LIVING
Some think life should be lived on the fast lane:
Racing cars, disco light, fast food and jet plane;
Some think living is best in the countryside:
In the flora and fauna they find their pride.
Well, you make living an art with what suits you;
A great art it is if the fallout none would rue.

(6) UNITY IN DIVERSITY
When the brook burbles between the leaves and rock:
Dawn chorus blends the tones of all, the dove and hawk.

(7) THORNS AND FLOWERS
In all aspects of life, you'd find thorns and flowers:
Sleazy shacks beside glittering city towers;
Massive talents emerging from slimy slum gutters;
Gilded jails for some starry-eyed gold diggers.

Thorns and flowers among lovely sons and daughters;
Thorns and flowers among great mothers and fathers;
Thorns and flowers in the clock chiming the hours;
Thorns and flowers as birds flap their wings and clean their feathers.

The hawk eyes the sparrow in sunshine and showers.
In the red-light zone, you'd find these among the hustlers.
Thorns and flowers among mediocrities and super powers.
Thorns and flowers from nursery to ivory towers.

Presidents, senators, governors and ministers.
Thorns and flowers far and near, novices and masters.
Thorns and flowers among shrine, mosque and church worshippers.
Thorns and flowers in a breeze that turns a gale and hollers

At buildings, then everything on its path down it hammers.
Thorns and flowers in a wave, once lovely, but raging shatters
Its barriers, throwing punches like boxers,
Overturning cars, flooding homes and sending down spines shivers.

Thorns and flowers in science – big bombs and computers,
Internet, smart phones and stalking virulent hackers.
'Thorns and flowers' is the song life sings in all quarters:
On land, up in the sky and deep in oceans and rivers.

(8) DAILY NEWS
{SUNUP}
Someone somewhere was duped by a con artist;
A gangster shot another gangster dead
As a wife murdered her husband in bed;
Then tale of a kidnapper and rapist...

[No, the newscaster's not through with the list.]
Bird flu, earthquake, suicide bombers, air raid;
Aids, prostitution rings and their trade...
[Below, the newsreader says, is more gist:]

An elected governor caught in London
With our stolen cash in his private safe;
Unemployed graduate shammed being dumb and deaf...
[The reader is yet with his news not done.]

Clash of religions; Palestine and Jews:
A big threat to world peace? I seek your views.

{NOON}
Yes, you had received the news at dawn;
Now, the reader serves you the part at noon:
Over-zealous Muslims kill Christians over cartoon;
US and terrorists at daggers drawn;

Tot stolen from cradle in parents' lawn;
Nuclear materials in the hands of a loon;
Another genocide in Africa soon?
Who, for Christ's sake, would rob a nun!

Hole keeps deepening at ozone layer;
Man marries dog, woman weds woman;
Gay consecrated as reverend gentleman;
Pop star abused a child and ends in slammer.

Please stay glued to your communication set
As fresh package at sunset you'd get.

{SUNDOWN}
Welcome to our daily news, last segment:
Famine inside Ethiopia, war at the border;
Tsunami toll makes the whole world shudder;
Sportsman banned for life for drug infringement;

Principal impregnated female student;
[Don't touch the dial, the reader goes further:]
Riots in schools as pupils attacked one another;
Did we sight in the skies an alien movement?

With twenty million you're a tourist to space
Where you can stare down at your hungry brothers;
And emerging straight from medical covers –
Genetics is set to breed a super race!

[We rest our case though not yet the end;
Further developments to your e-box we'd send.]

(9) THE SURGEON

He was born to see his own mother thrive
Around the kitchen - it suited her well.
His father the very same point did drive:
Kitchen to women is like water to well.

He sent the boys, even the dullard, to school
While his sisters took early to trade.
His father told them life is for men to rule;
It was good to equip he who'd be the head.

Like his father before him, Pa Ben
Had same belief and treated his kids the same.
Though every one of his female children was brain;
He made them materials to cook for men.

He had a heart problem and the woman-surgeon
Was his daughter's mate who studied in London.

(10) MY TRUE PAL

Most times I refuse to go along
With the crowd for everything I do I think;
I ask why I should dance to a song:
Must I also pour to Val shrine my drink?

I'd never bought the idea of love
Being a thing dressed and showcased in a mall.
Love should be for all days, smooth and rough;
It should cascade our homes like waterfall.

I know a lot in your head you may ask.
Whatever, love for me is a lifetime task.
As they celebrate and abuse the term 'val' -
That is, love for a day in a whole year
But you for life I make my true pal;
Everyday, your pendant on my neck I bear.

(11) JANUARY – DECEMBER (ACROSTIC)
Just hang on till your dream does click.
Attack it with all your mind and might.
Nurture it with passion and care
Until it hatches into reality's chick.
Accept failure but change not the dream you bear;
Resolve to carry your very dream to light.
You surely success' lollipop would lick.

Fall in, let us steer round to some robust economics:
Every goal achieved has opportunity cost;
Building empire means you'd take some dire risks;
Rounding up time for something means time for others is lost.
Unless you stop gallivanting, time would be scant;
Add discipline to yourself and every dream you'd realize;
Raise the bar – shun things that to your goals aren't at a slant –
Yeah, grabbing goals means to reckless fun you'd shut your eyes.

Marching gradually deep into the New Year:
All resolutions kept or have you broken some?
Realign yourself if so but if a beam you wear
Cause the right boot isn't on wrong foot worn -
Hold on tight and see your game this year is won.

All around me, crops and trees richly bear fruits:
Pears, corn, papayas, avocados and mangoes;
Rain has returned to help water their roots;
In the farms, people work the ground with their hoes.
Let's learn from them – still time our dream seeds to sow.

May we rest a bit and pray for decent rain
All the seeds we'd sown to water and make them grow
Yielding in due time dividends to our greatest gain.

Jolly well learn to rest and work at same time;
Unclutter your life's page and nicely punctuate it.
Never lose sight of your goal as anything else is a crime;
Endeavour, notwithstanding the hiccups, a great end to hit.

Just keep praying and working to be the best;
Utilize all chances more in you to invest;
Lessen frivolities that'd steal from your nest;
Your hard work and prudence dictate your harvest.

All your great dreams – have they come to fruition?
Unclear still is the path of your vision?
Grab your thinking cap (it's not late) and re-dream.
Unless you move, you'd get stuck and without a beam.
Search hard to see what you could haul in with your net.
Take time to explore, exploit and update.

So the 'ember' months so soon are back?
Everyone everywhere seems to remember
Promises made – are they on or off track?
To those whose goals have been realized,
Excitement beckons as they ride
Magnificently the tail end of the year
But for those not sure, they're gripped with fear.
Enter the last phase with great caution;
Race to win but within regulation.

Oodles of dreams, hopes and despair
Certainly litter every calendar.
The paramount thing is don't fear
Or relent to perform better.
Being bold is the best way to go;
Enthusiasm you must borrow;
Resolve contentment too to know.

Now, like jest the year draws to a close.
One might just wonder if all along you doze.
Vexation might eat you up if in your task
Every now and then you've failed or you'd just bask
Mightily if in it you do excel.
But should we place our worth in the one-year scale?
Emphasize being and doing your best daily;
Race always with a winning mentality.

December draws the year to a close.
Everyone's ears seem to stand on tiptoes
Checking the airwaves for awesome news.
Engaging in blows or forging truce
Mainly because of clothes and food would
Be partners in every neighbourhood.
Envy and strife would turn harlot
Roaming homes and shops to bite a lot.

(12) RELIGION

It crept into our soil from East and West,
Creeper that promised to bear enviable fruit,
Fruit heathens would eat and joyously live
As they'd all come to know and discern the truth.

One creeper branch crept from across the desert
With a robust stem, bearing massive roots;
It bestrode seas, lakes and rivers
Promising to bear big, juicy and luscious fruit.

The other crept across the ocean, landed at the coast
With a robust stem bearing buoyant roots
Promising a future time of plenty as it goes
When the heathens would've all embraced the truth.

The massive creeper with its robust stem
Has bestrode all our hamlets and cities,
Bear sturdy roots hard to remove or tame
And presently showing signs of a predatory beast.

The scented flowers on the creeper's stem
Are bearing thorns, no more luscious fruit.
The truth-seekers all stand dazed and confused
As the remnant heathens wag fingers at them.

(13) THIRTY YEARS AGO
Thirty years ago I was taught:
Honesty does richly pay.
Thirty years after, that proves nought:
Cutting corners remains the way.
Our society exalts dubious men;
Past crimes are erased with strokes of pen.
If from being honest you can't change;
Expect your reward from heaven then.

Thirty years ago I was taught:
Giving generously is a virtue;
Thirty years after that proves nought:
It seems now like givers stay blue.
Our society promotes hoarding:
Everyone thinks of self and their kin.
Respect goes to those hard and mean.
Heaven helps if giving lies in your vein.

(14) THE COMPLIANT TENANT
I kicked my legs out of bed
At the cheers of children
On seeing the lights on –
The electricity board had withheld
Electricity for two weeks now;
Had just brought it back as it was month's end
Meaning they would come soon
With the electricity bills.
How they know and bill every house
I don't know cause our house
And over ten thousand other houses
(Except for a handful of corporate buildings)
Have no metres.

'Up NEPA!' the children cheered
Even though the electricity board
Had changed their name
From NEPA (National Electric Power Authority)
To PHCN (Power Holding Company of Nigeria)
But dissatisfied folks still call them
'NEPA' – meaning: 'Never Expect Power Always'.

The children cheered and rushed
Into the houses and soon TV's were
Showing music videos where half-nude ladies
Gyrated their hips and buttocks
And the men constantly pulled at their groins.

I moved drowsily across the carpet,
Plugged in my stabilizer and switched on power.
I plugged in my phones.
Though I have a telly and a DVD player,
The telly was out and I didn't enjoy
Playing music and not watching the dance –
Devilish gyrations that make me cringe
To think what my pastor would think
If he were to see me watch these graphic videos.

My landlord collected the rent in advance –
I always complied paying him in advance;
Paid him in January the rents for the entire year.
Then my roof leaked and I told him about
The leakage and he got angry
And asked: 'What do you want me to do?'
'To repair the roof, sir,' I said.
'I have no money, my friend!' he said.
'But I paid you in advance,' I said.
'And so what?' my landlord screamed.
I left him quietly as I wanted no scene
And then the next day the rain fell heavily
And the roof leaked and water dripped into
My extension socket and I didn't know
And when power came on
I plugged my electronics
And I smelt something like plastic burning
And I desperately looked around
And realized smoke was coming out
Of the extension and rushed and pulled off
The stabilizer from the main socket.
My TV went off and never came on again.

I walked back to my bed
As I was still feeling drowsy.
The blare of the electronics filled the air
As holidaying children were all in watching TV.
Last night, my landlord tied a randy he-goat
He caught roaming our compound
And harassing every other goat in sight;
He tied it to a pillar just beside my room
And the blankety-blank thing bleated like
It had the cold blade of a butcher's knife
Pressed against its jugular.
It bleated like hell cause it was prevented
From mating and left in the cold
Because it strayed and not allowed

To mingle with my landlord's she-goats
Which were tucked away in a warm room
With a couple of immature he-goats.

The randy he-goat was dying with envy.
It was moaning and weeping
And hissing and cursing and thumping its hooves.
And I, denied of sleep all night,
Wondered why my landlord thought it was wise
That I who complied with all his rules
He should punish the most.

(15) ARTWORKS
I should've fretted, used to fret, but decided not to today;
Thought I shouldn't care, shouldn't my nerves anymore fray.
I live with a sad man who seems to me to draw complete joy
When he realizes that with others' feelings he can toy.
It rained this fateful day, mortar and bricks I mean.
I left the lectures, I should've been bothered within.
As an amateur artist, I was loaded with cardboards
From mates who thought I was good making patches of hue.
I walked into the tenement – there were puddles on all floors.
Tenants thought I'd pop with madness and teach our landlord a lesson or two.
But I was calm, mopped my floor and put my things on dryer spots.
I painted, even on the darker pieces, what stood out were colourful dots.
That day in my sodden room I realized life isn't all bleak
If constantly within you, faith would love sincerely seek.

(16) SPORTSMANSHIP
I love football – the World Cup is here again.
I watch every match with the big screen
In the open with every friend.
We chat, pontificate and scream.
We guess which team which trophy must attain.
Culprits receive our blame.

Flame of ire
We do direct
At poor playing and coaching.

Rooting for country's native to my brain.
I also love to cheer the best team;
Beam if we win as match ends:
We clap and leap and hoot and stream
Out to the streets in a victorious train.
We chant best players' names.

Games get dire
If refs inject
Bias while officiating.

Flinging missiles at anyone I won't do:
You win – we shake hands and with that I'm through.

(17) ROSE IN A BIN
Tell me, dry petals
Of rose in a bin:
When awash with beauty
And smelling ever so sweet,
How many hands chased you?
And when you were callously ravished,
How many crooked hands and nostrils
Kissed and fondled your delicate frame?
Now that you are limp,
And have passed the threshold of your prime,
Is this the treatment meted out to you –
Being dumped in this putrid bin?
Then you must be wishing
For your freshness once again.

(18) LIFE IS A JUNGLE
In the jUnGlE,
Life is one BIG sTrUgGlE
Between

c
r
e
e
p
e
r
s

[AND]

T
r
e
e
s.

They t I
Nw
iT
En
eR

(Yes, the creepers and trees intertwine).

BabOOns
Use them to
Climb leisurely uP [or] DOwn.

Life is a jungle, you better realize:
Others are at the fringe as you fight
Ever ready to reap from your plight.

(19) DEATH

Death, simply, is this:
That one sweet kiss
That had refused to remain;
That winsome smile
You'd never wish bye
But you'd never see again.

Death is the sun
That is long gone
Even after the rain
Would not emerge again.

(20) MY WINDOW

Every day I look through my open window
At the sweaty faces on the street below
Beating an old rhythm with their worn heels –
The dreary music of daily survival drills.

Beggars move up and down with familiar lines:
The constant tunes that hard are these times;
Indicting the helmsman that our fat oil sales
Are reflecting on citizens less and less.

The oven of survival burns extremely hot
Just like our moral fabric suffers glaring rot.
These sad things I perceive through my window every day
And wonder if from them can't we a little stay away.

(21) NEEDLESS ARGUMENTS

From the start was chaos so argument must persist
For my dawn seems to be noon in your place;
Same continent, same humans, we argue about race
And fight over faith forever we can't resist.

The search for truth tops our arguing list:
How many ways are there to divine grace?
Would we by our piety and zeal see God's face
And force Satan from evil to desist?

Even in same tribe, we look for royal stock;
Same faith we argue over denominations.
One people, we think different nations;
We kill to show a hen is not a cock.

Needless argument keeps breeding horror and gloom
And daily we keep sliding to our peril and doom.

(22) HAPPINESS IS …

Happiness is being in a big party
And noted for making the most noise.
We talk loud, wolf down food and drink silly –
Then we're drunk and wobbly, losing our poise.

We harass girls, fight their men and stab some;
We drag ourselves out there to our car
And race home at a speed that's quite gruesome;
Then the car swerves, hitting a roadside bar:

Screams, clanging metal and shattered glasses
Tailed by a moment of uneasy calm;
Then the rude awakening sensing the bruises –
A torn knee, broken rib and bandaged palm.

Yes, happiness is being helplessly drunk;
Then ending in a ward with a bandaged trunk.

(23) FREEDOM OF THE STRAY

'I've been in this cage for so long,' he says,
'It's high time I've got to run and stray.'
He devised schemes as passing were the days
Till that day arrived he did venture away.

He ran from alleys to lanes to avenues
And then reached the vast and sprawling highways;
The parks and beaches were such lovely views
But getting to the crowds he saw nightmares.

Wicked stares were shot at his direction;
And raised arms bearing missiles did him taunt.
Not long the stray dog was in confusion
As viciousness in men's eyes did him haunt.

Doggy thinks now as hunger booms:
Freedom without discipline indeed dooms.

(24) TENT OF HOPE
It rained on me in the jungle –
Keen blades of cold stabbed through
To my innards.
I was a statue, numbed,
In the dungeon of cacophonous leaves,
Leaves speaking the discordant tongues of rage,
Raining on me dead leaves and grime.
I was plastered with dirt
From eyes to the soles of my feet.
The gloom deepened.
Leaves smarted me into desperation.
Stiffening and shivering, I groped –
Tripping over roots on the rugged tracks –
Towards the beckoning fire in the tent
Where I'd roast my trunk and limbs
After bathing and sponging off the sludge
Still creeping on my flesh.

When I'm caught and drenched by life's rain,
I look up to the fire in the tent of hope.

(25) TONGUE IN CHEEK
(INTRO: Irony is the cream with which a people under despotic roof openly rob, I mean, rub their minds.)

PROLOGUE:
Our huge oil exports
Are placing undue weight
On our nation's coffers –
Come join relieve this oppression;
Let's move into politricks
And elevate our dear nation.

AGENDA:
Let's tar our roads with potholes
And bless our people with waterless taps;
Let's equip our schools
With strikes, crowded cells
And hunger-made-mad teachers;
Let's upgrade our hospitals
To mere morgues
And send the doctors on foreign errands;
Let's garland our entire workforce
With arrears of salaries
And rain our markets
With substandard and highly priced goods.

EPILOGUE:
Come, let's ennoble our dear nation
With our excesses –
Let's defraud, pillage and kill
For these are grand benefits of demotecracy.

(26) NOW IS THE TIME
While the summer sun
Of our youth keeps shining –
What with it do we do?
Do we go junketing,
Forgetting the frigid winter
Of hoariness that lurks around?
The ants gather while food abounds
Knowing scarcity will come.
Let's gather now
Or for a certainty know
A wood that refuses
To burn in dry season
Would scarcely
Catch fire in the wet.
Now the sun still shines,
Let's straighten our paths;
Lest the hoary night,
With its dreadful blights,
Crept on us
And groaningly we hobbled home.

Now is the time to pave our paths
While our summer-long sun still shines.

(27) WE KNOW EACH OTHER
We do not know each other
But earnestly we know each other.
We know each other
Through someone who knows us.

You know someone who knows
Someone who knows someone else
Who knows me or still someone else
Who knows my parents, siblings or friends.

I know someone who knows
Someone who knows someone else
Who knows you or still some other person
Who happens to be quite close to you.

As long as we interact with others,
No matter what strata we belong to,
We know one another for surely through
A chain-like knowing we know someone
Who knows someone else who knows you or me.

(28) PORTRAITS OF POLITICS
(i)

The crimson stage is set and the bloody clowns
One by one are sauntering in.
They've taken off their flowing gowns
And at the legs we see what hangs between.

Too keen to be different, ha-ha,
Wacky crab struts sideways into the arena.
And Bat thinking he could steal the Zany Crown
Resolves to sleep hanging upside down.
Then gentleman Pig, in zest to tidy things,
Pushes and leaves his balls at the rear to cling.

Ah, humour has skinned mouth of lips:
Teeth must bare their shapes and colour today.
Tears are sliding down the walls of the cheeks;
Tears for a giant perpetually on the stray.

Democracy! My sides are aching and bursting –
I'm wallowing in this laughter and groaning.
Democracy! Must the actors in the open peel off their gowns?
Can't we get acts and scenes devoid of heart-rending clowns?

(ii)

This politics is plain harmattan
Cracking lips, dusting hair and crinkling skin.
Leaves scorch at the ceaseless blow of her fan;
Chill permeates pores, organs and every vein.

Familiar walls spring icy slaps on our backs;
Water in familiar bowls stings our hands.
Familiar throats throw forth voice laced with cracks
For the freeze has mopped the oil from the glands.

Who hit these testy drums in harmattan
And wouldn't even bother to moisten the skin?
Sheer folly is this crooked drummer's plan.
Has vindictiveness sliced our nous so thin?

Who throws sparks around flammable forest attire?
Be wary. This season's scary - it befriends fire.

(iii)

Assemblies of toads, frogs, kites, vultures and hawks:
Altercation and predation are your tangible stock.
You croak, fight for spoils and yourselves mock –
Other beings having a good show directing their gawks.

Presidency of hippopotamuses and elephants;
All you do is trample the woods and moats.
You relish terrifying the fish, fowl and goats;
You care not if dying are grasshoppers, butterflies and ants.

Governorship of monkeys, hyenas and dogs:
You chatter and howl your unalloyed grassroots support
While stashing your loots far across our port
And then grub and grab our treasures like hogs.

(iv)
I had conjectured
Initially
It was the familiar hoots
As rumour is a bird
That flies our crimson skies,
Alighting on our muddled barns.
Then Third Term grew iron fists
Suddenly
And rammed into Aso Rock:
The glass windows, doors
And furniture
Smashed into smithereens,
Are tumbling and clinking
Deafeningly.
Now, eyes popping,
The nation stares
To ascertain if vermin
Of double-speak, half-truths,
Lies and betrayals
Truly
Are co-tenants of the villa.

(29) SMOKY CHIMNEY
Hone the cigarette sword with a lighter,
Then stab yourself wittingly through the mouth;
See it race in like a deadly fighter
Looking for victims east, west, north and south.

Roast your organs in the smoky chimney
Of deadly tar, nicotine and soot.
Surgeon General's caution is just blarney:
Burning stick indeed makes you look cute.

Cuteness ceases when lungs pack up with cough
And shortness of breath called emphysema;
Cancer quite soon will challenge your bluff
Unless you make smoking an anathema.

Resist that bloke and staunchly shun that smoke:
Smoking isn't joke – your organs soon it'd choke.

(30) THE INTERNET (TO EVERY CHILD)
I'd greatly prowled the Internet, dearie, I would say;
Prowled its mystical and fun-filled paths;
Met hosts of lovely characters, home and away
But the Net too has imps stalking its boulevards.

Prowl if you must; indeed in today's world, you must
For it's the fondest and fastest means that connects
But learn to distinguish right and wrong; unfair and just
For in the Net butterflies can morph into hornets.

Know what you download and watch who you chat with.
Ignore doubtful attachments and if someone's heckling you
With requests mum and dad wouldn't be glad with –
Block them or tell mum and dad before they do something you'd rue.

Make the Internet worthwhile as much as you can
But run away fast if someone is bent to cause you harm.

(31) I'M YOUR FAN
A toad's a clown, mimicking the nightingale;
Lion owns strength, camouflage wears chameleon;
The scientist may be poor weaving a tale;
Good shoulders make a weightlifting champion.

Talents, no matter how massive, have limits;
They differ just as the earth is from the sky;
Same theatre the nurse to the doctor submits;
Talent plus hard work would propel one high.

Sometimes we misdirect our energy and talent –
Heard of the mugger who turned out boxing legend?
Sometimes we just miss it all, lacking the vent;
Sit back, search within and to what you find, attend.

For me I'm keeping at my pen long as I can;
Keep at the good thing you do and I'm your fan.

(32) TRAVELS

Travels expand mind:
Rocks, seas, beasts, birds in other lands
Show our Creator's grand.

(33) LIFE'S RAINBOW

Stars, moon, sun and rain;
Sea, sky, land: all they contain
Paints life its rainbow.

(34) NATURE

Nature donning her
Gleaming green gear sashays along
The catwalk of spring.

(35) IMAGINATION

When you saw flies growing wings and flying,
You taught spiders to build web and trap these;
To dispel cold you started fire burning
So we could warm our numb hands, feet and knees.

Milling in streams and rivers are fish;
For our meals we catch the fish with hooks.
So to be wise, knowledgeable and rich
Some tips we readily garner in books.

Extensive oceans span every continent
But ships remain its permanent feature.
I unearth the past, explore the present
And with you alone I take the future.

I ascribe to you, Old Man Imagination,
The sole fatherhood of creation.

(36) POETRY, LORD OF WORDS
Language being the big city it is
Has innumerable words as its citizens;
Occupying mountaintops and abyss
Are multiple and colourful denizens.

Vulgar occupies the slimy gutter
As informal inhabits the city's wings.
Through its elevated and gold-framed shutter,
Formal surveys his lesser fellow beings.

Prose in basic form is mortar and bricks;
It is also the plain track and alley.
Poetry is marble and polished sticks;
It's also the toll-imposed carriageway.

In the land of words, prose is the subject;
Poetry over prose lords with grand effect.

(37) MY PEN
I've smuggled sunshine
Into someone's gloomy days
With you;
I've harvested roses
From the barbs of hard times
With you;
I've coaxed friendship
From a sworn enemy
With you;
But for the friends
I've mistakenly pierced in the guts
With you –
I prostrate for forgiveness.

Yet for the souls
Filled with filthy junk
Of hate, rancour and greed;

Be the acid eating away at them
And let the bitterness
Of the truth dripping from you
Seep in ever deeper
And I certainly have no regrets.

(38) THE WORLD BEST
I know you had read that piece I once wrote:
It bears my views and too my name.
Shame, that I penned such thrash
And went round thinking what some fame.
I thought I'd scripted the world's finest note –
'Poom!' it went down with a crash.

Rash it'd been
And premature
The joy which welled in my chest.

Rest of tale is my joy's now a mere mote;
For all I got, me alone I blame –
Lame was grammar, rhyme brash;
It was not fit even for kid's game.
Like political misfit I lost my vote –
Oh God, that was a bash.

Harsh you'd been
And immature;
The piece will change to world's best!

Jest as you like and spit and then burn it;
Sit and watch - I'd work and around turn it.

(39) THE TALEBEARER

He came with his zipper down;
Said he had bad news from heart of town:
My wife, my wife – he did repeatedly mourn –
Was caught red-handed early in the morn
With a strange face in a secluded pub.
When back did I beat her to a pulp!
Each blow was with the tale of her deed
And a tirade about her unquenchable greed.

My wife was shocked beyond words;
And then she explained where she was.
I verified and found it to be true
And for weeks I was terribly blue.
The talebearers would come with tales to tell,
Running, minding not who they hurt or fell –
With hair unkempt, zipper loose and all that
Just like someone utterly going mad.

(40) JUST WISHING CANNOT MAKE YOU A WRITER

Just wishing cannot make you a writer;
You've got to get down and slug it out.
Put your fine ideas in many a letter;
If they're good you'd sure get the praising shout.

Enough of your bright chats – bend over that paper;
Put pen to work, paint your imagery with words;
Let the picture be clear, your words clever;
Let's feel without seeing what's in those pods.

Not easy being a person of letter?
But I know you love that aura of clout.
Don't tell me so soon it's a back-breaker;
Please, buckle down and really slug it out.

Now, you've tried it what more do you say?
Please, hang on – try more. Don't call it a day.

(41) THE ONE THING I TRULY ENJOY
Butterfly's swinging flight, bright colours of its wings;
Heron's formation flying, songbird's sweet strains as it sings
Make me happy – earnestly I've such great feel.
Things in life like the surging waves and the rainbow;
The warm sunshine, trickling brook and waving meadow
Bring me happiness – indeed I get a big thrill.

Painting observations in life with well chosen words
And realizing they'd go far to soothe aches and fill voids
Give me happiness – in fact, I have boundless joy.
Carving figures of words and erecting them on papers
And knowing they'd impact positively on the minds of others
Long after I'm gone is one thing I truly enjoy.

(42) WHAT REALLY MATTERS
If in your mansion with a swimming pool,
Marble floor and chandeliers in every room;
High-tech gadgets and many a gilt stool
And the rooms daily get a vacuum;

Remember in this complex it's a small space
You'd dump your frame after every daily race
But if evading is sleep – oh, what a waste
If all your struggles wrong things you'd embrace.

What really matters is your peace of mind;
You miss it all if your life isn't with it timed.

You're like a bird with charming plumage
But that is forever stuck on the ground;
Its treasures others readily would pillage –
The fox and kite near your home would prowl around.

(43) CITY WHIRLPOOL

Thick, funny accents
Thrown from multifarious ethnic throngs
Tumble unrestrainedly
In this murky, swirling pool
That sucks down as well as throws up …
Spinning whirligig of pent-up emotion
Littered with social and religious traits –
Grave threats! –
Which sometimes whoosh and hiss
At our reeling sense of balance …

In the city whirlpool,
The straight and crooked swirl together
As they twist and turn,
Ascend and descend,
Chasing freedom
That mean money, forever spinning
And racing, might bring.

(44) IMMATURITY

Immaturity could rob one's future joy
As it blinds one and you chuck solid gold
But with abandon scramble after gilt toy.

Immaturity could make one throw away the gem in hand
But go swimming across the vast ocean
Searching and digging for same gem in a faraway land.

Acidic is the unripe guava of immaturity:
Bite on it carefully or else
One's joy's teeth would grate permanently.

(45) POETRY RESTAURANT (ACROSTIC)

Put on your best apparel, sweetheart;
Out to the best bar let me take you.
Eat the best meat – kebab or gizzard?
Take ice cream as you look at the menu.
Relax, I'd refresh your body and mind;
You'd get everything, even the best wine.

Reach for whatever you desire:
Every food for body and mind;
Such goodies to take joy higher –
Treat so special it's rare to find its kind.
Ah, draw close – let me whisper something nice:
Unending treat that to life is spice;
Real fabulous meals in a posh bar.
After, I'll take you home in a posh car.
Not for a day but for all time
Tenderly in poetry bar you'd dine.

(46) VISIBLE IN A DARK ROOM

I heard croaks of your complaints
Of what fluorescent light
Could've drawn the flying insects
Of a beauty queen
To that ugly and penniless bloke;
Of what strong root
Could've made her trip and sprawl
For such dunderhead (as you tagged him)
Instead of the rich and charming you.

The high moon of ignorance
Has drought the owls' hoots of wisdom –
It sure beats the ordinary mind.
But whatever is the strength;
Yes, the stealthy forces that pull
And bind a queen's supple hand
To the straggly limb of an ugly bloke,

Gives her whirls of happiness and laughter
(If not seen in broad daylight)
Is clearly visible in a darkroom.

(47) BEADS OF LOVE

Today I wake with this religious vow
Of being a monk and you my monastery;
Then I step into your temple and bow
Just as my fingers nurse this rosary.
Reverently, I sit on the prayer mat
In a praying pose facing the rising sun:
I gaze till I first see a dove, then a bat;
I relax till I feel nothing but numb;
Counting the beads and purging my mind
Of the junk thoughts I harbour behind …

I drone as I fiddle Bead One:
Sweetheart, if you are really gone
It doesn't mean I must forever mourn.
Then rue as I move to Bead Two:
If your love has fizzled out –
Someone else's is bubbling up.
Now on Bead Three – it's still the old me:
Don't expect me to sadly pout,
Brood, get enraged or even sob.
I purr as I roll to Bead Four:
Even though I was wrong (now I know)
To think this love wouldn't sourly go.

I thrive again fiddling Bead Five:
Definitely, love is gone;
I've got to rise and move on.
I'm a bit uneasy on Bead Six:
Life's got so much to offer –
So why must I in self-pity burn?
Bead Seven either isn't heaven:
You've got a new lover –
Great then, go ahead and have fun.

My teeth grate as I move to Bead Eight:
Now you gloat a better guy got you.
Ta-ta. The best girl got me too!

I whine as my fingers nurse Bead Nine:
I beg you, let your love unfreeze;
Flow now and caress me like the breeze.
It's sheer pain as I reach Bead Ten:
Stop roasting me like the tropical sun
But to my taste buds like honey be fun;
I peep heaven as I seek Bead Eleven:
Add value to my life like wisdom;
Let your love to my wings be true freedom.
Into a lie I delve as I reach Bead Twelve:
Don't hesitate, don't linger long;
If you miss this, you miss love if I'm gone.
I grin nastily as I hit Bead Thirteen:
If you know my worth after the deed's done;
Please, be strong, take heart and turn a nun!

Now on Bead Fourteen, I can't help but hum
(And I'm surprised with you I'm not yet done!)
I'd thought love is a two-way thing
And for the drivers approaching …
I sing as I swiftly roll to Bead Fifteen:
From both ends of it enough space
Should be allowed for a smooth race.
Then a sting on my mind as I hit Bead Sixteen:
You're stalling the traffic, sweet!
You're sitting tight at mid-street!
My shin twitches as I reach Bead Seventeen:
Oh well, please, give me the break;
You're heartlessly marching the brake!

I fling these questions at Bead Eighteen:
Are you branching off left or right?
Are your indicators all right?
On Bead Nineteen I now croak than sing:

Can't you even gesticulate with your hands?
Don't you know communication oils romance?
It's pure misery as I get to Bead twenty:
What do I do with a stone-cold heart
And a love that tastes awfully tart?
I moan as I twiddle Bead Twenty-one:
I'd love you still; I'd love you – though tough –
Till I could melt the ice of your frozen love …
I'm through (I think) as I hit Bead Twenty-two:
With the white heat of my enduring passion;
I'd love you till you give me your whole attention!
Bead Twenty-three I face the demons to be free:
This maiden has never been the problem –
Your complex ways alone bear the blame!
I pour further the truth at Bead Twenty-four:
You've done catharsis with your pen;
You pretend to cope as with all men!
The big lie is confronted on Bead Twenty-five:
You drag her into the middle of the road;
Being malleable, you fixed her in this mold!
On Bead Twenty-six I leave the dark the light to kiss:
Naïve and trusting she's been toeing
Every path to her you've been showing …
I lessen my burden at Bead Twenty-seven:
You are the culprit with your workaholicism
And a cheat with your intellectual egoism.
On bead Twenty-eight, it's clear I'm earnestly done;
From here to the ninety-ninth bead I'd hum this song:
From now on, sweet, you'd be my monastery
And I, the monk, devoted to this rosary!

The End

www.ingramcontent.com/pod-product-compliance
Lightning Source LLC
Chambersburg PA
CBHW030739180526
45157CB00008BA/3238

www.ingramcontent.com/pod-product-compliance
Lightning Source LLC
Chambersburg PA
CBHW030739180526
45157CB00008BA/3238